trip

This edition published in the United States in 1999
by powerHouse Books, a division of powerHouse
Cultural Entertainment, Inc.
180 Varick Street, Suite 1302, New York, NY 10014-4606
telephone 212 604 9074, fax 212 366 5247
e-mail: info@powerHouseBooks.com
web site: http://www.powerHouseBooks.com

By arrangement with Dewi Lewis Publishing, England
All rights reserved.

Photographs © 1999 Susan Lipper
Text © 1999 Frederick Barthelme
Introduction © 1999 Matthew Drutt
For the US edition © 1999 powerHouse Cultural
Entertainment, Inc.

Library of Congress Cataloging-in-Publication Data

Lipper, Susan
Trip / photographs by Susan Lipper;
text by Frederick Barthelme;
afterword by Matthew Drutt. — 1st ed.
p. cm.
ISBN 1-57687-051-0
1. Photography, Artistic.
2. Lipper, Susan. I. Barthelme, Frederick, 1943- II. Title.
TR654 .L45967 1999
779' .092- -dc21

99-32084

CIP

Hardcover ISBN 1-57687-051-0

Design: Joseph Guglietti Design
Printed and bound in Italy by EBS, Verona

10 9 8 7 6 5 4 3 2 1

photographs by SUSAN LIPPER

text by FREDERICK BARTHELME

powerHouse Books
NEW YORK, NEW YORK

t r

i p

On the highway outside Lake Charles it was all cars and trucks, stopped, moving — all *populated*. The river bridge dead ahead. "How did I get here?" she wondered when she got out to take the picture. The reasons weren't clear even to passersby. They thought maybe she worked for the state.

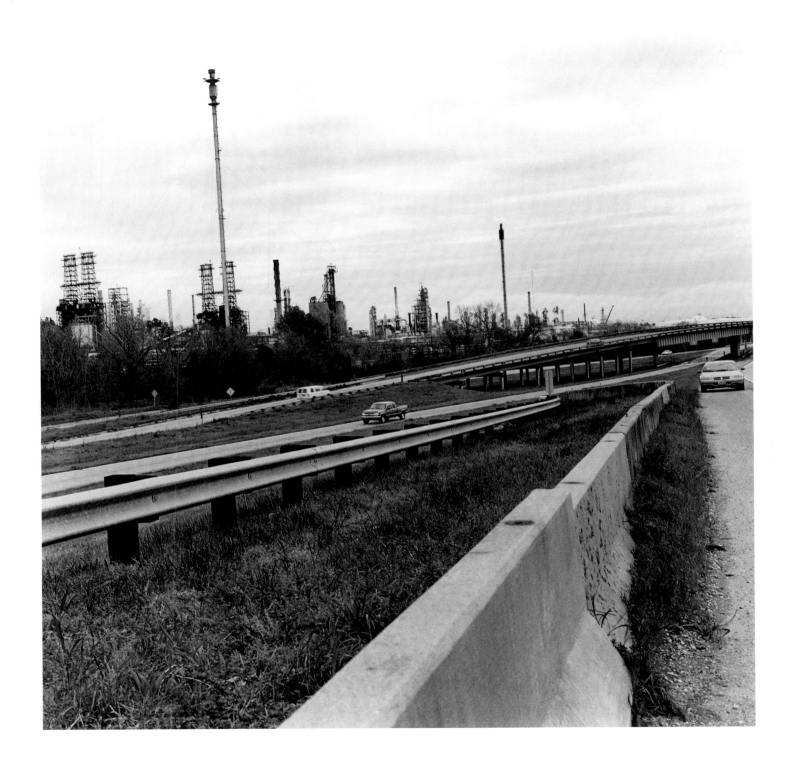

She kept the bigger things in there so that they didn't
get beat up by the tourists. You'd be amazed what
damage a thousand hands can do in a day.

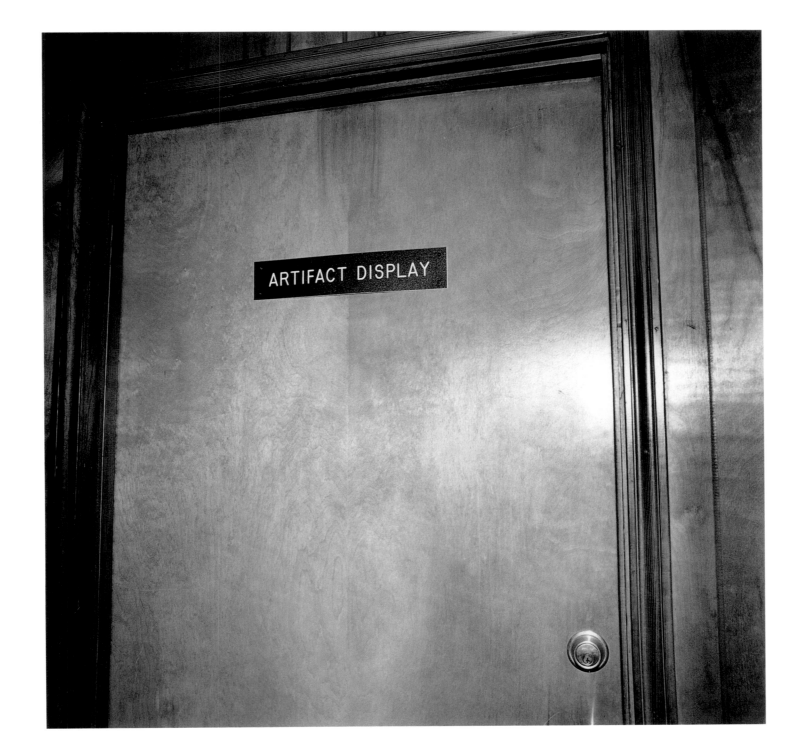

The fountain wasn't working, just a little dribble of
fatigued water and then a peek at the birds beyond —
all the species indigenous to the area, captured and
displayed. But she had to have come through the door
first, that was the hard part.

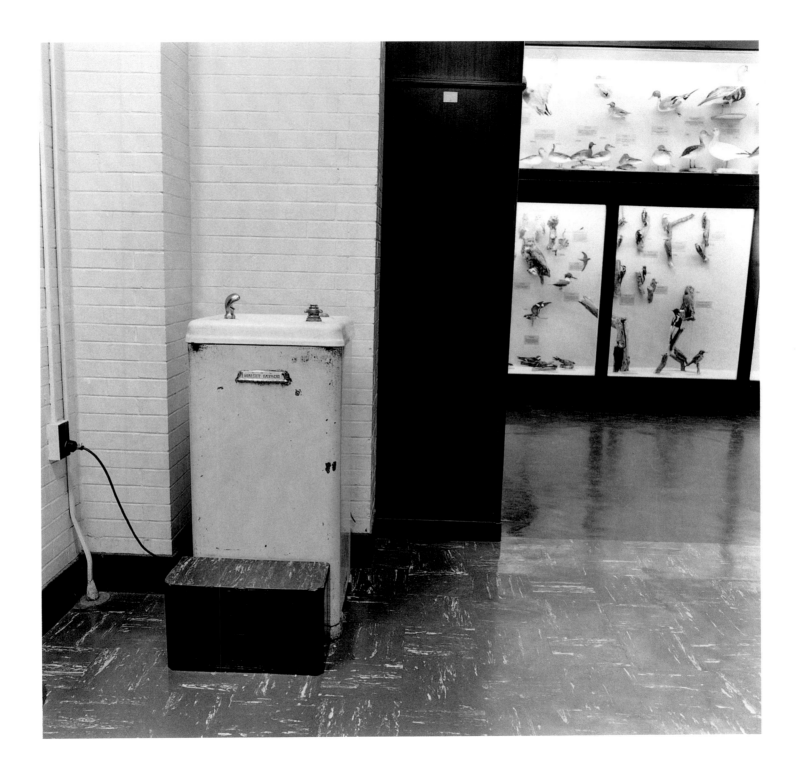

At four in the morning she cleaned up the tiny kitchen in the room, wiped the counters and the floor, and rinsed out the sink with soap, then alcohol, and then packed up all the garbage she could find in the room and took it out to the Dumpster at the back of the property.

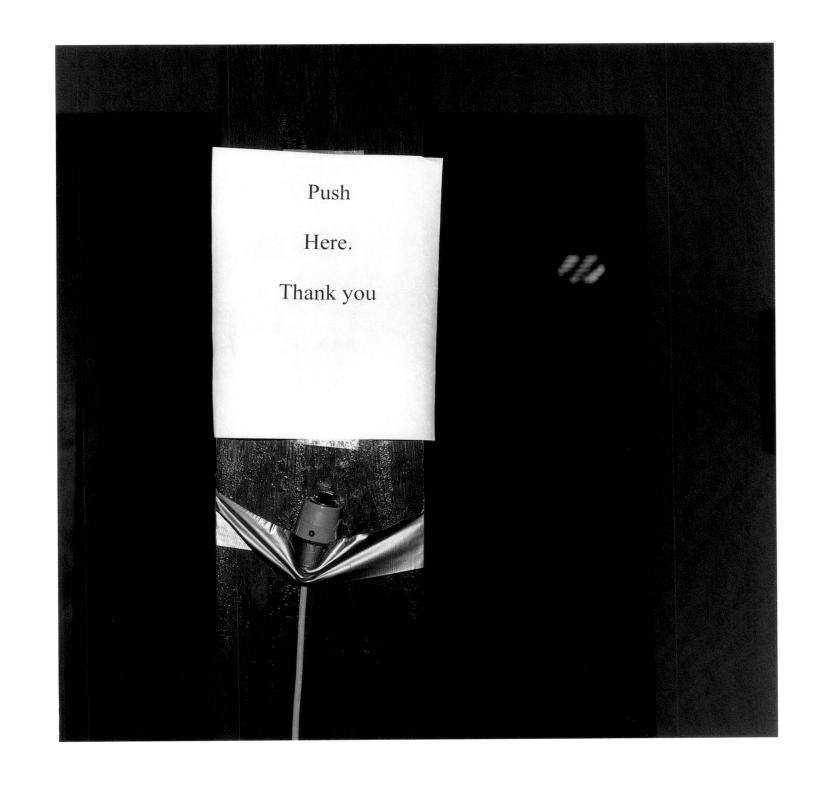

Only one street lamp burned about a hundred and fifty yards down the road. Everything seemed to have lost its power. She stood on the corner in front of the Tropic Breeze, then walked out into the middle of the empty highway.

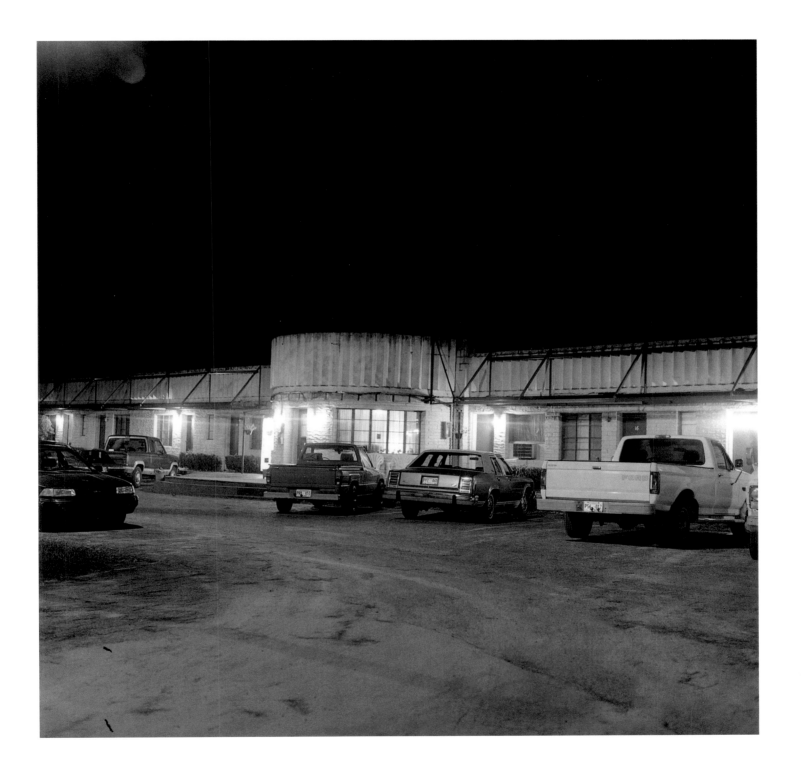

She had something pretty good going there for a time, but the expectations were high and specific. To some of those people it was all rockabilly.

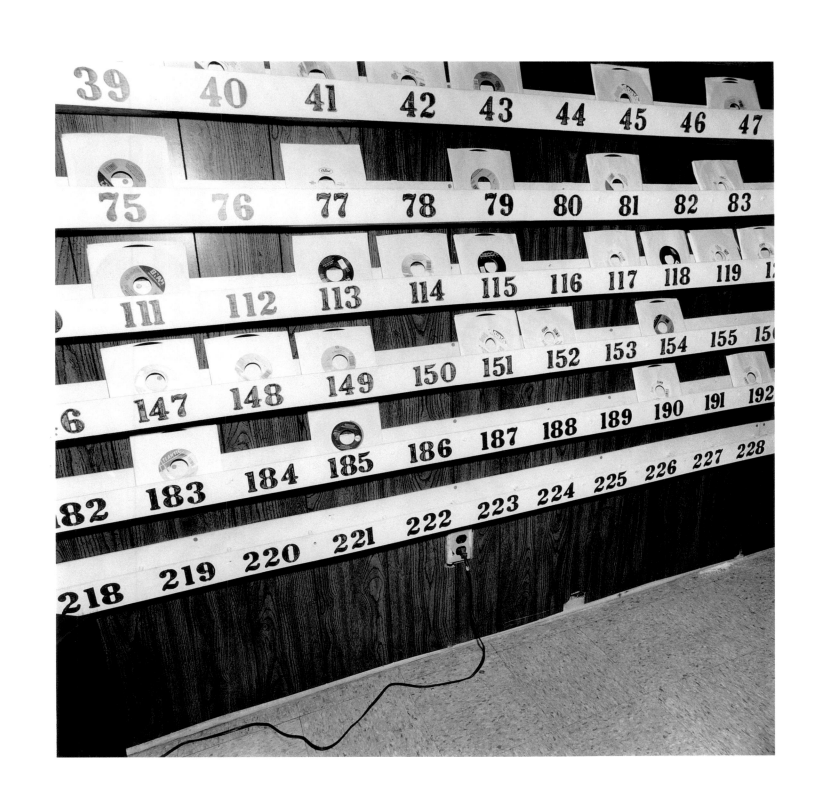

The air was peculiar, the way it just hung there, motionless, just drifting off the water, and the only sound was the faint hiss of little car brakes running up tight behind her.

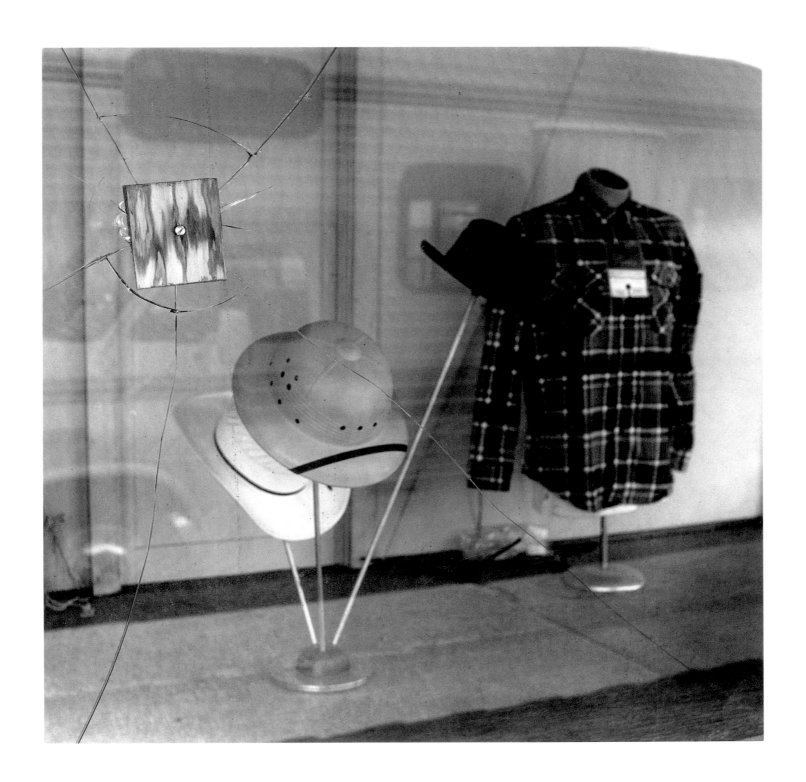

There weren't any cars on 90. She crossed to the beach side where the sand was gritty under her shoes, then came back, looking all around, soaking up every sign. A perfect site for Tetsuo III.

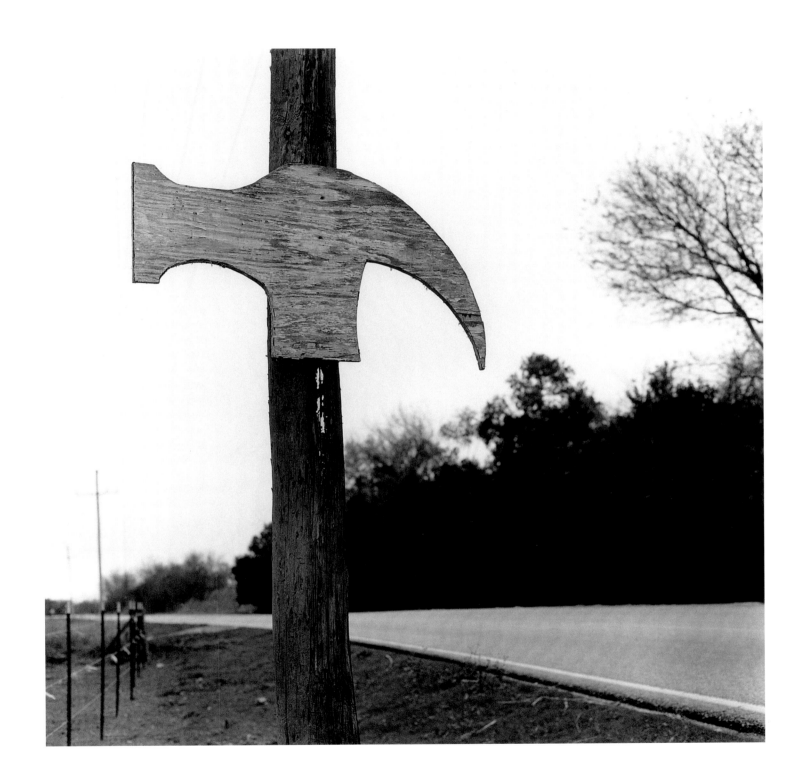

She found herself on the wall of fame and switched the numbers — she became 32 and let the other girl be 38.

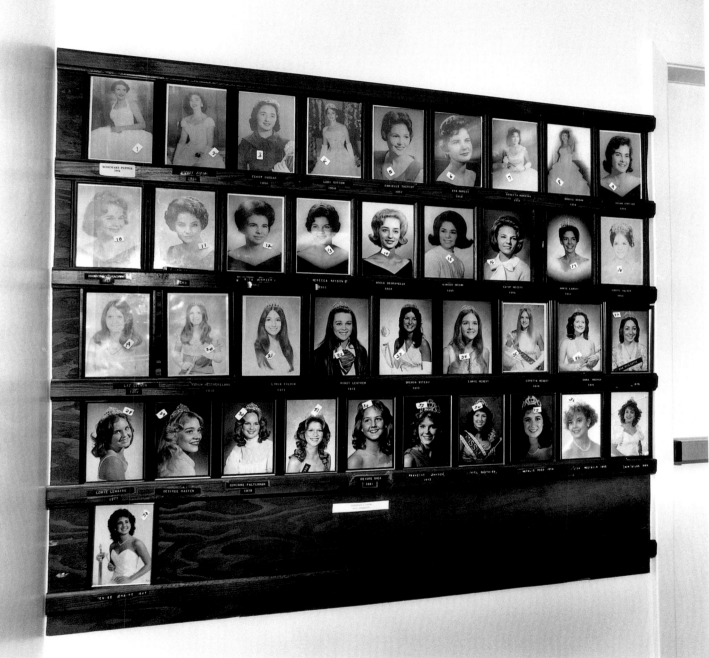

She sat on the porch with her father, who was this wrinkled small man in khakis and flannel. He rocked all the time, day and night. He had been County Clerk at some point, but things had gone haywire. She never got what it was.

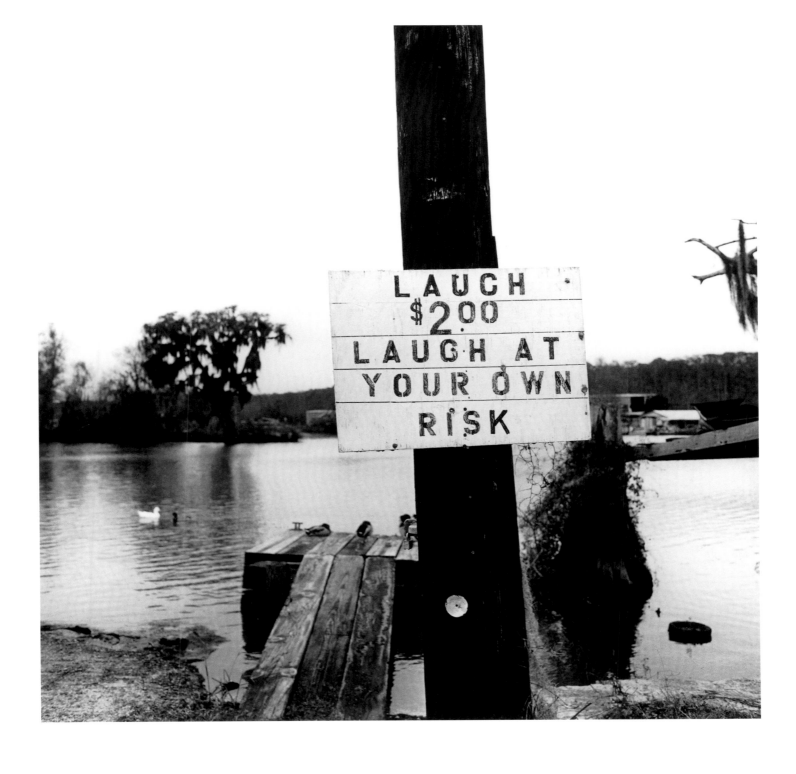

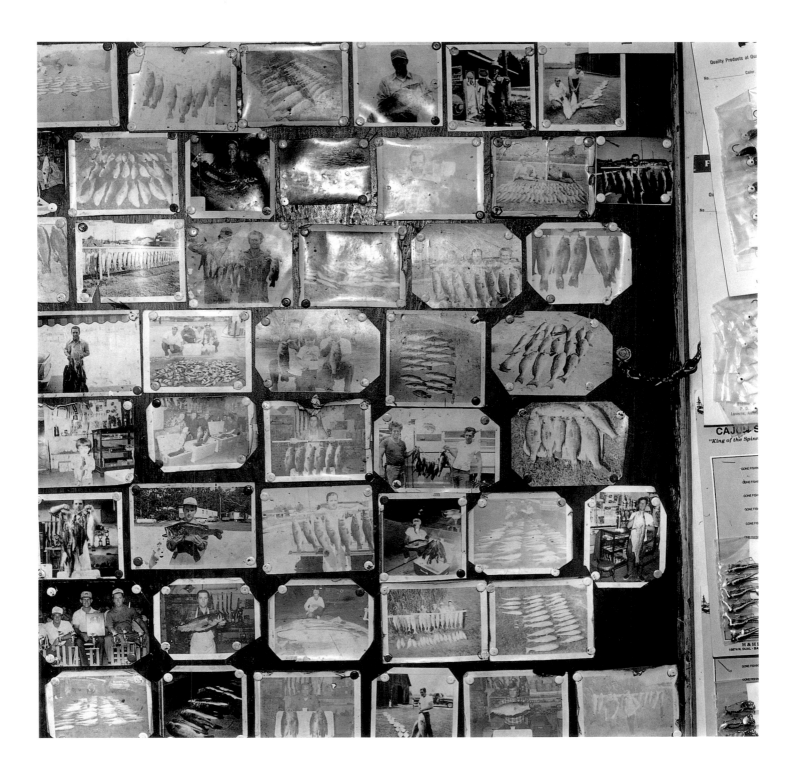

That a corner was a complicated altar to populate was
a bit of business to which she was born.

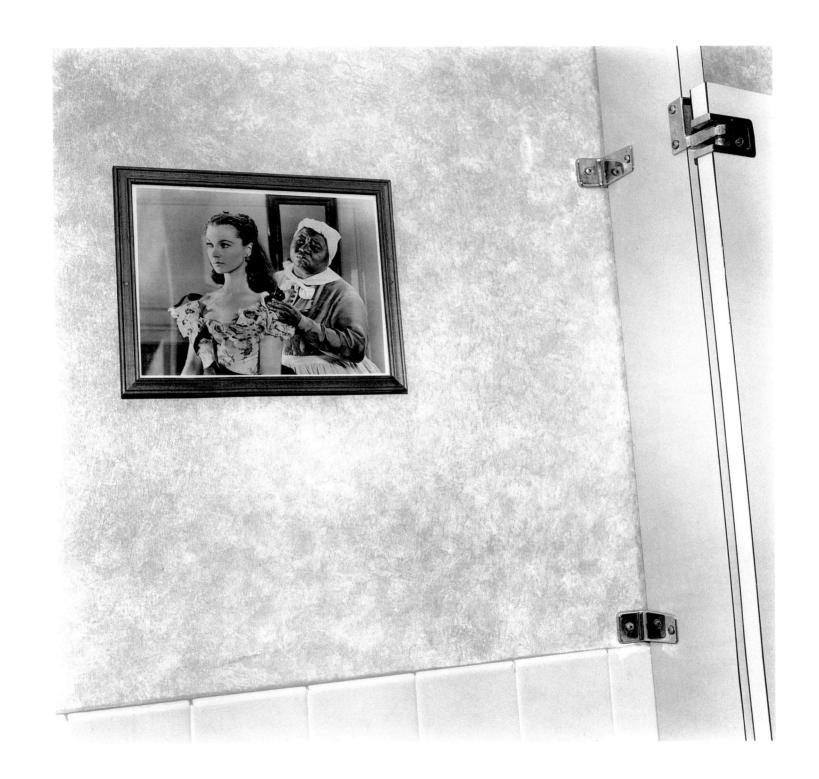

Then they were up and into the bathroom together with Cokes he brought from the kitchen and bath oil she found in her overnight bag. He sat on the floor next to the tub, leaning against the wall, and talked to her as she bathed, and when she was done and out, and wrapped in a big towel, she returned the favor, sitting with him as he bathed, and telling him about a woman she'd run into at Dance City where she'd gone to buy leg warmers.

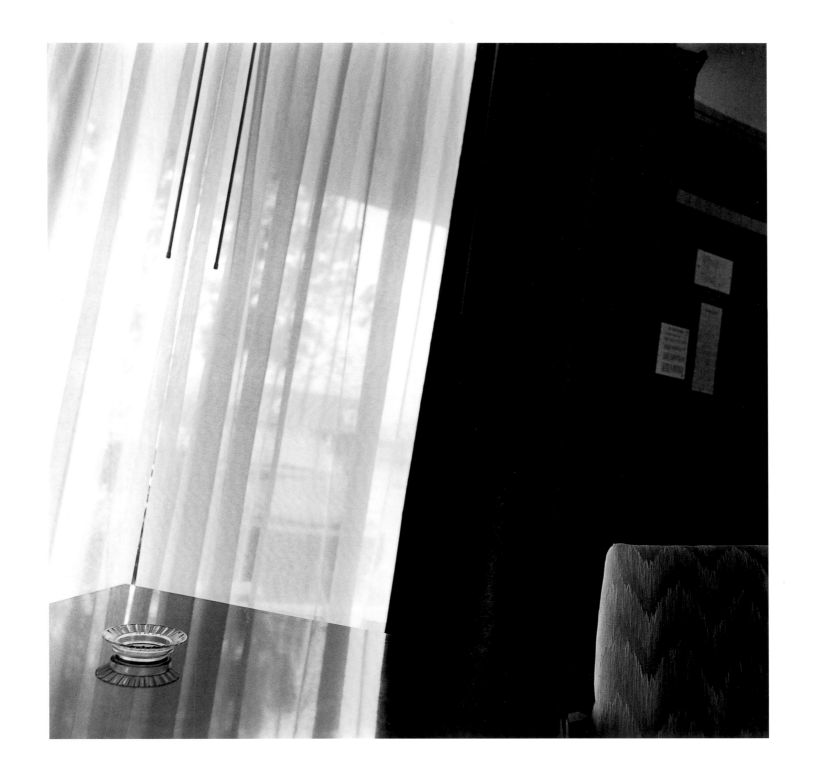

The house was like a helicopter for her. It could have taken off at any minute, and she'd never be aboard.

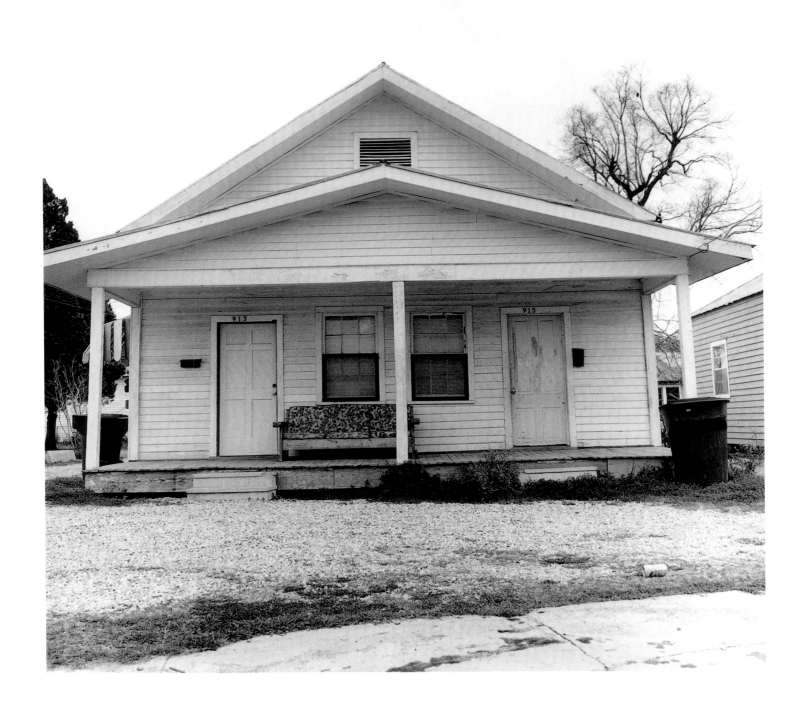

Hit by a car and left for dead, is what she told everyone. Could have been worse, but he died anyway. They were not made for each other in the first place; it was all put your little foot, put your little foot, all the time, that's all she ever said. She...well, she danced like a tiger, but told him she was ready to just stand there for him, if that's what he needed.

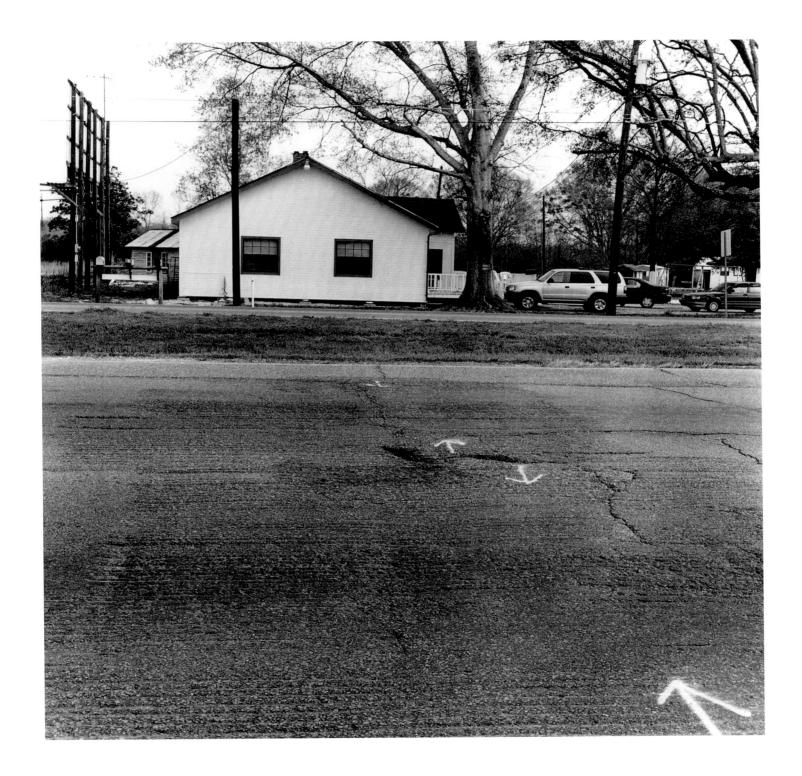

She slid her hands through her hair to freshen it, then stretched out for a minute on the second bed, her hands by her sides, her eyes shut. He got up and went into the bath to turn off the shower for her, and stopped to kiss her forehead when he came back, then started clicking off the channels.

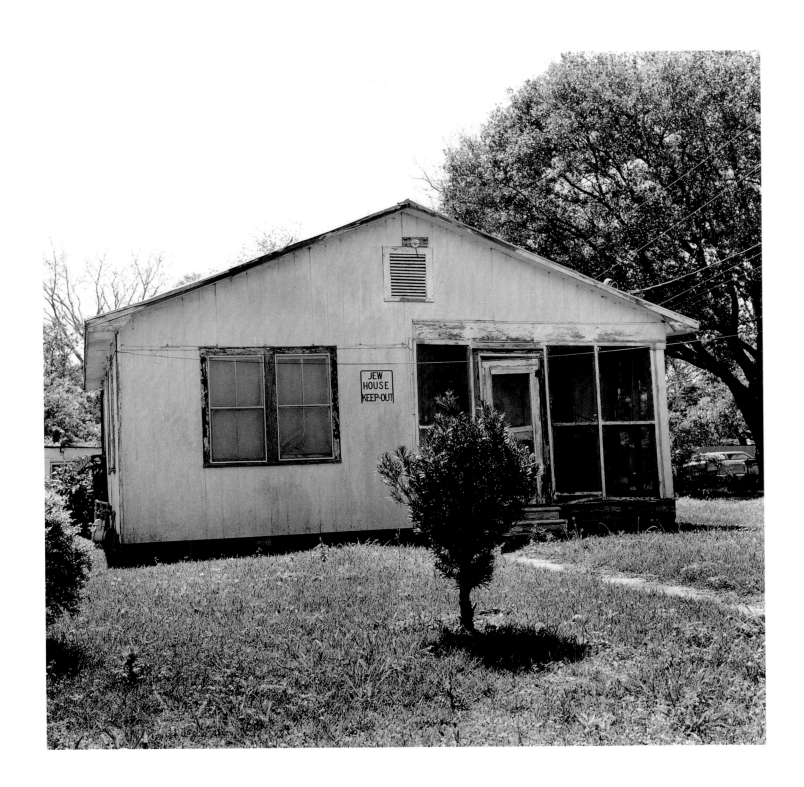

She said his real name was Larry and he'd improved his lot considerably, expanding the bikini business by branching out into sno-cones, rentals on flotation devices, umbrellas, Sunfish, Rollerblades, volleyball equipment, and water wings, plus entrepreneurial deals like beachfront valet parking, sunscreen delivery systems, small foods, and so on. He had a new Chevy van with an aftermarket nine-thousand-dollar paint job from one of the local hot rod shops featuring severed Medusa-heads pulled from boxes swamped in elegant lime and teal flames. In the nineties the world was full of hard choices.

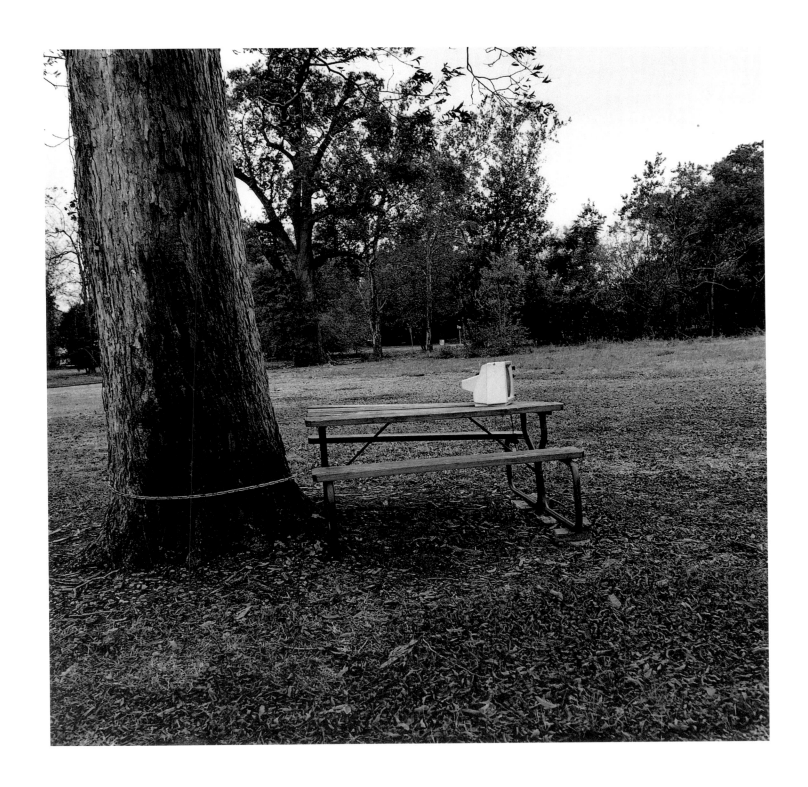

She holed up in a country shack with some geese and an instructional video and when nobody was looking dodged around among the damp trees like a furtive angel. There was no telling what she was after, but pretty soon all the townsfolk queued up, rapt, to see what was next. Nobody went away untouched.

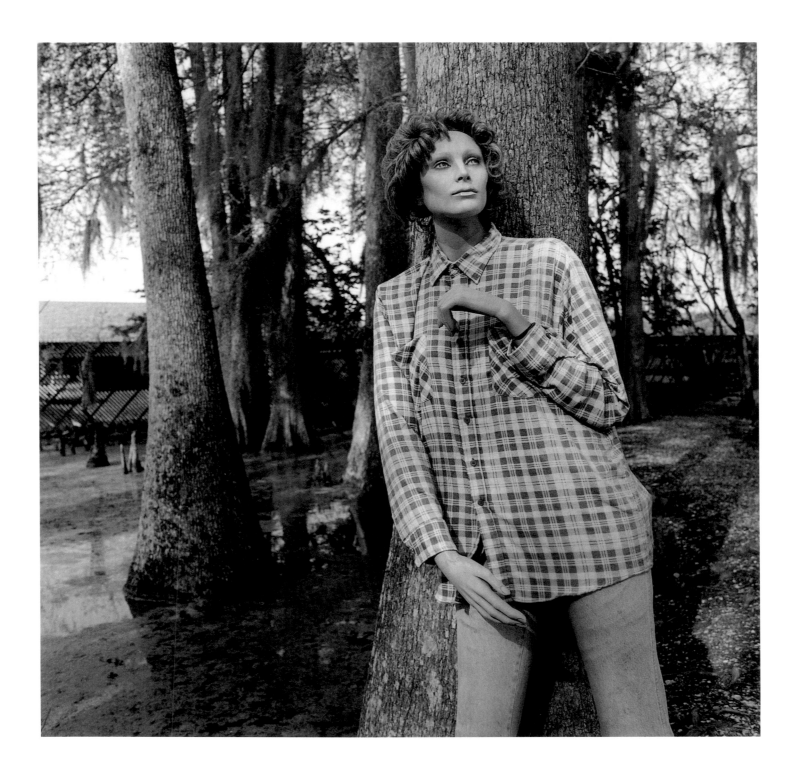

The guy she met had prickly hair that shivered as he talked. He was a tubby guy, couldn't have been more than five-six, five-seven, and must have weighed one-ninety. He had a squarish face and head, almost like a small stereo speaker on his shoulders. His hair stuck out an inch in all directions in a crew cut from the fifties that she got the feeling was going to retain its viability right through the turn of the century.

MILK	50	
COFFEE	40	

SLUSH PUPP

SM	MD	LG
93	59	79

★ HAVE NIC E

DA

The people seemed peculiar to her, just off normal —
wrong size, wrong color, wrong shape, wrong posture.
One guy had on these big, black corduroy shoes — they
must have been sixteens or seventeens. Loafers that
looked more like model cars. Another guy was so thin
he looked like a chopstick with ink on top. She could
have wrapped her thumb and forefinger around his
ankles. There were gaudy women, greasy-looking men,
too much hair combed with combs with tines too far
apart so you got that Robert DeNiro hair like when
Robert DeNiro was doing the remake of that Robert
Mitchum movie. People were sneezing all over the
place. They did a lot of actual size stuff, too. Actual
size trees. Like that. She had to be careful.

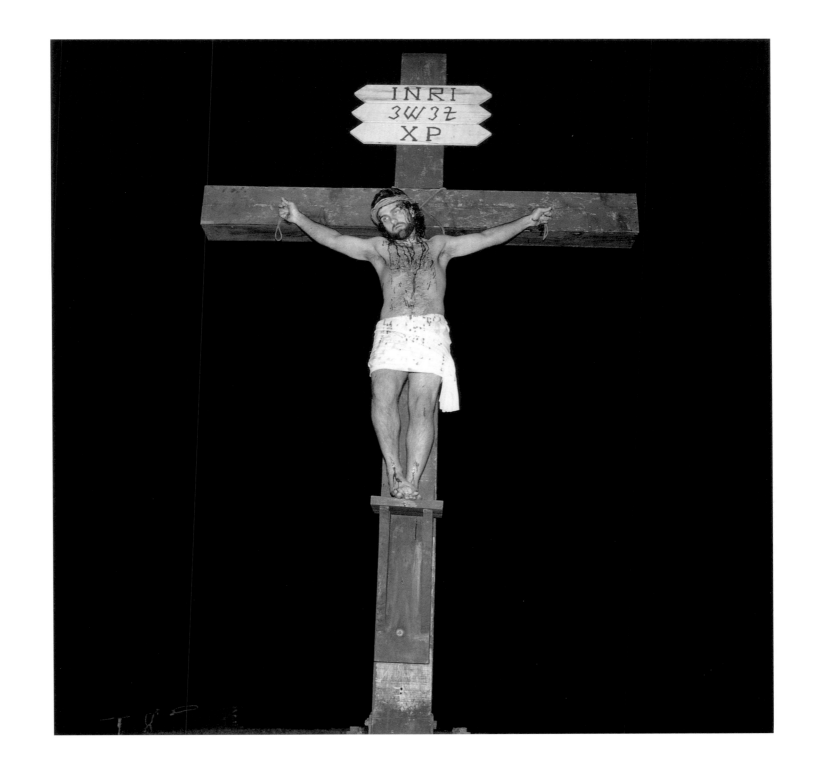

She wanted to plug his mouth full of letters and then
just sit there to see what words came out.

He called her on the telephone and told her he'd bought two thousand dollars' worth of grass, centipede grass, something like ten pallets of grass, because he said that would bring her back. When she didn't come he never unpacked it, never put it down, just kept those pallets in the yard and watered them all the damn time, as if they were pet fish or something, water always running out the driveway — he was nuts for that grass.

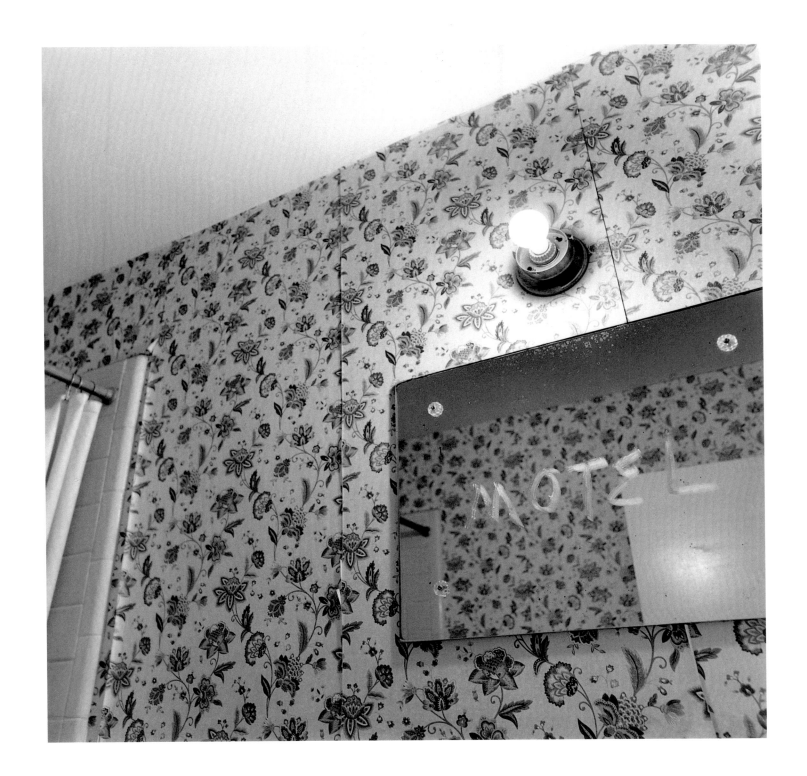

When she was getting ready for bed she handled the clothes as she took them off. She was neither too casual nor too precious with them. She put them down carefully but not too carefully. She folded her jeans, then folded them again. She draped her shirt over the back of a chair. She put her socks and shoes at attention at the foot of the chair. She looked good in underpants. She looked healthy and young and charmingly awkward. Her skin was only lightly freckled. Her back curved in a pretty way. Her breasts were small and delicate, suggesting adolescence, just hinting that way. Her knees had curious wrinkles.

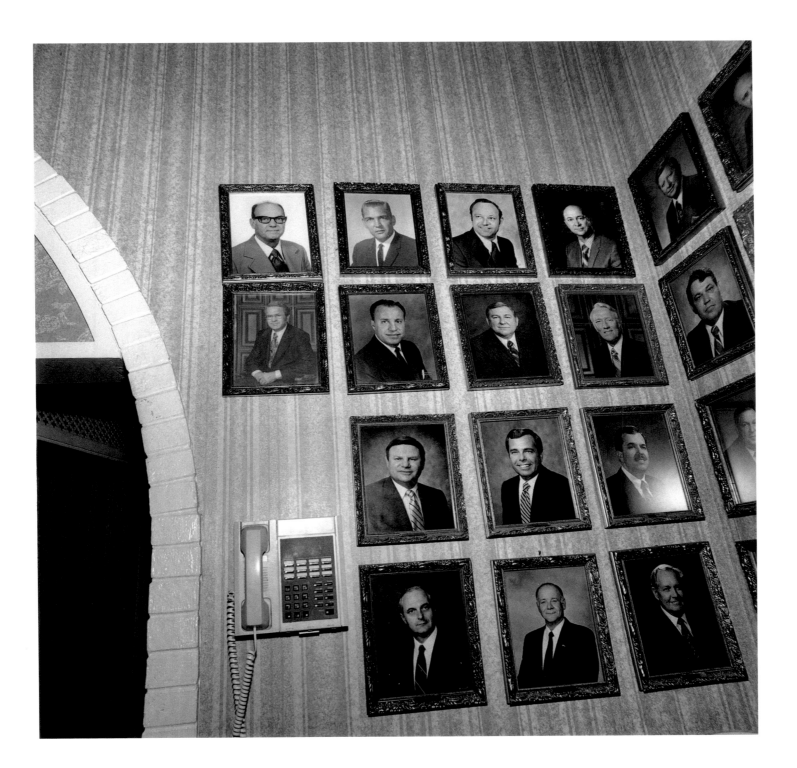

So . . . this is what she was talking about? Man, it's great, it's killer. Who ever knew it looked this good?

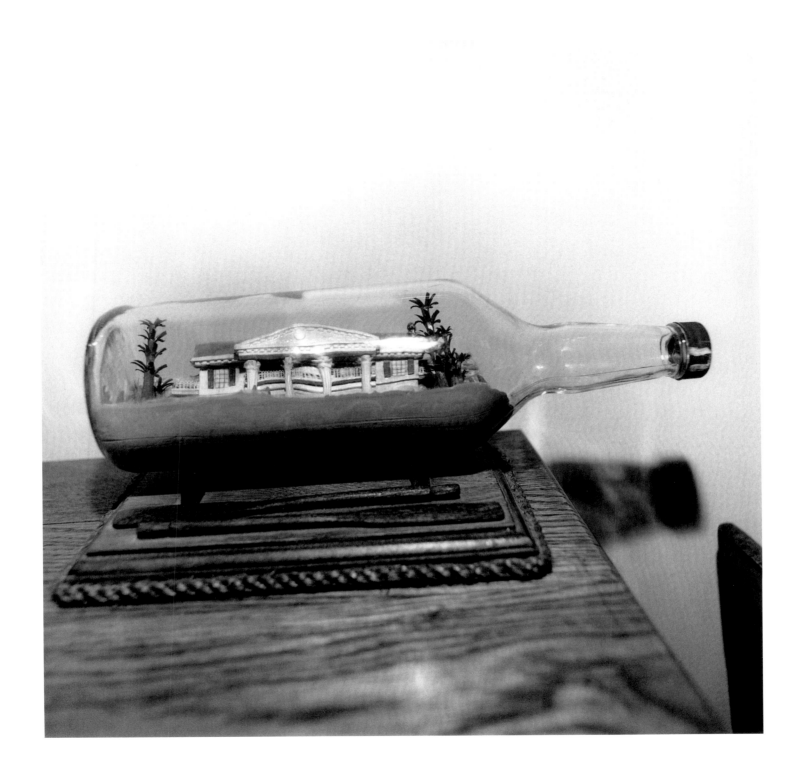

She had a plastic bird spitting water into a disk the size of a pie plate that overflowed into a small rubber pool — blue, it was bright blue, maybe six foot, a kid thing, seahorses on it. It was a parody of a fountain, or a memory of one, something she'd always wanted since she was a kid and saw pictures in a house magazine, water garden, and this was her version, and it was lovely, too, and she sat there by it sometimes.

He was dead, is all. She was there with him and wouldn't leave his side until the paramedics pried her off him and leaned her up against a mirror so she could see exactly what was happening.

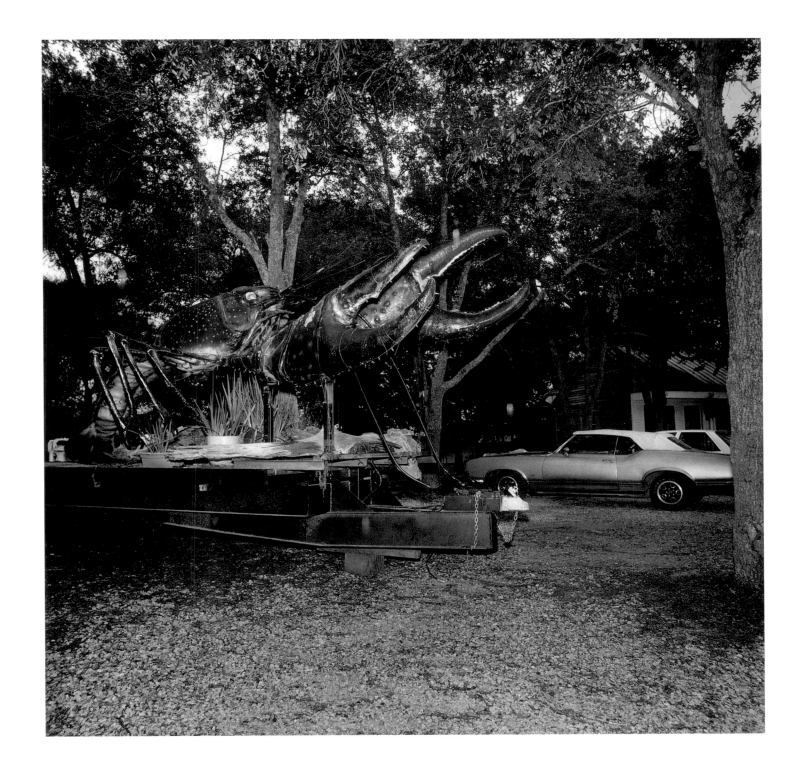

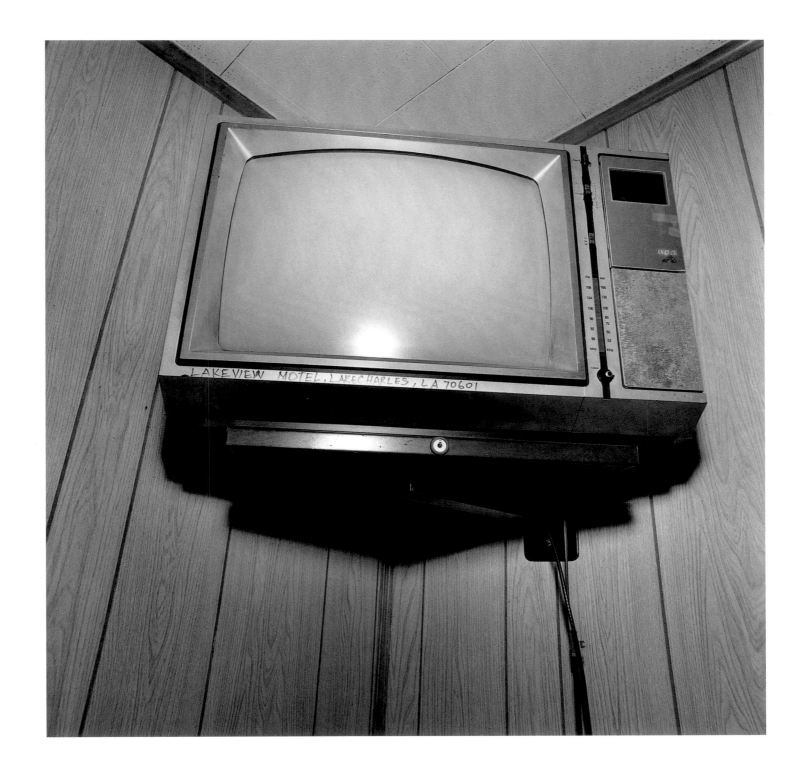

"Quit calling me every five minutes," she told him. "If I'd wanted you around I could've stayed there, now couldn't I? Man, you just all the time bear down, don't you? What? Oh yeah, I'm out here getting into trouble. You watch me, huh? This is the best I've ever had it. I'm just waiting for the man of my dreams to swing in through that big brown door. Wheelchair accessible. Man, I gotta decorate this place before he gets here. I gotta do my hair."

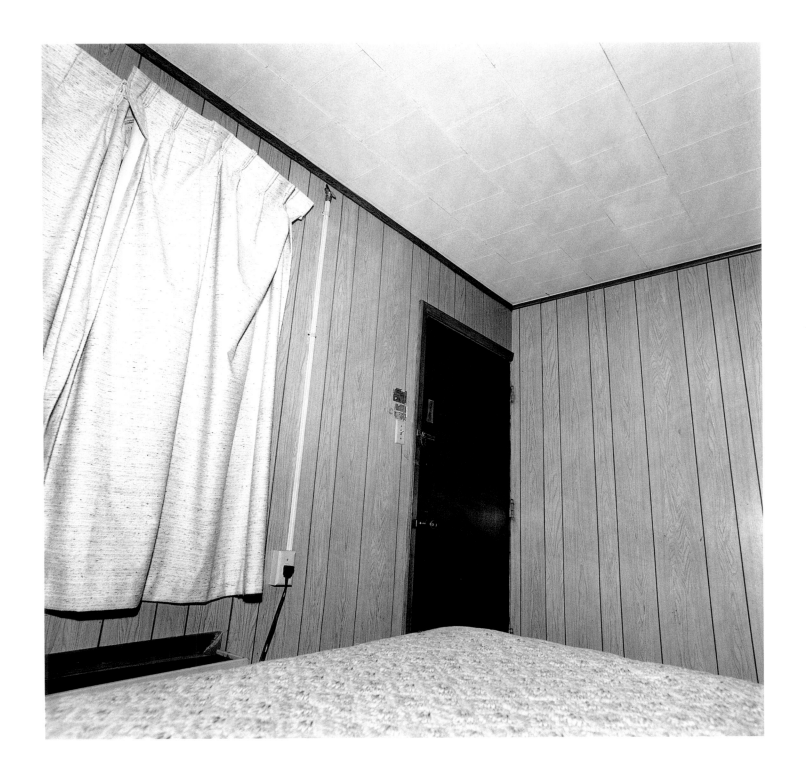

On her second trip through town she found a little dive called the Cabana Motel where some rooms were lit up and the office sat at one end of the property with a badly damaged neon sign. There was a shell lot in front of eight white cottages spaced out along a tiny creek running diagonally through the property. These were the cabanas, she figured. Next morning they were pressed up against each other in a jewel-green leatherette booth in the Cabana Cafe sharing some toast, which they'd cut in half on the plate. He hadn't shaved or spoken since the night before. She opened the paper.

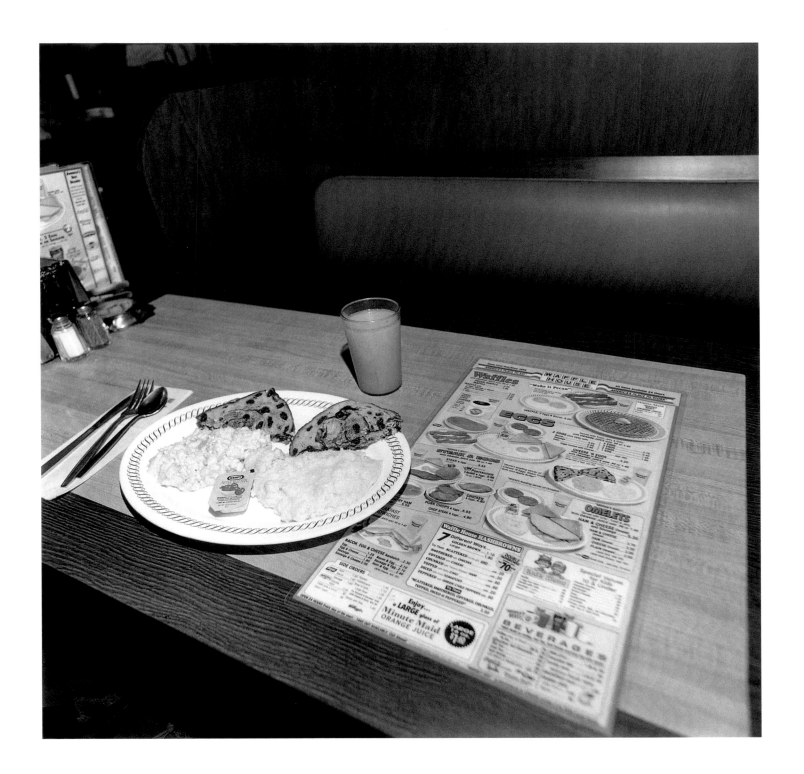

She never thought romance would come her way. In all the years since her sister married the lapsed priest from St. Michael's she never once thought that the exact same thing might one day happen to her. Yet here they were, at the bay, and he wasn't going anywhere. Sometimes she got into his things and brought them out, made him get into the priest clothes right up to that stiff white collar. Then she'd kneel beside him, her on the floor, him sitting on the end of the sofa, and confess everything she'd ever done.

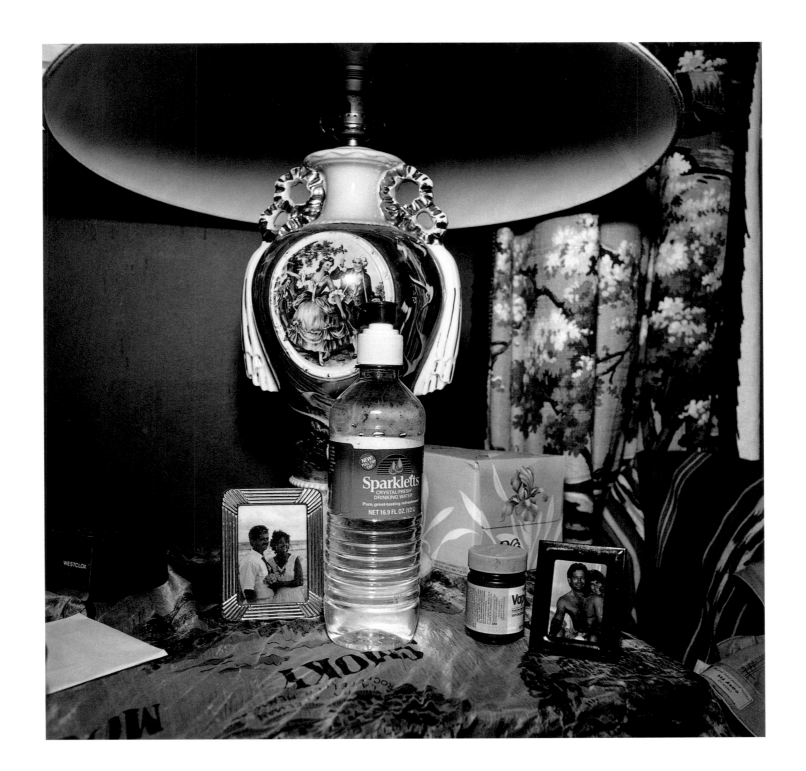

At the interview she asked and was told that the rooms there went on endlessly. "Don't think we're limited here — nine, nineteen, ninety-nine, we can handle the whole litter," the manager said. "It's not just about space, either. Or suggestion. Or memory. There's a lock on every single one of these doors."

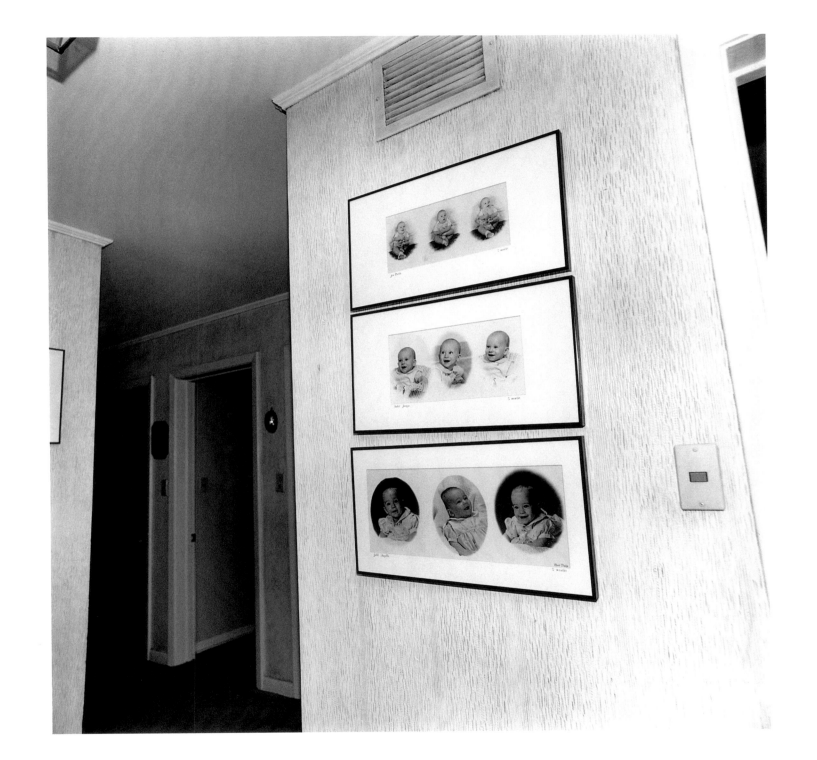

He was the mayor. That was her mistake. He had guns in his car. He was a big guy and he scared her sometimes. She'd get too close and he'd stick her up with a pistol and start talking to her like she was supposed to give herself the instructions — "Tell her to tighten down," he'd say. "Tell her to do it all. Tell her she's an orchid."

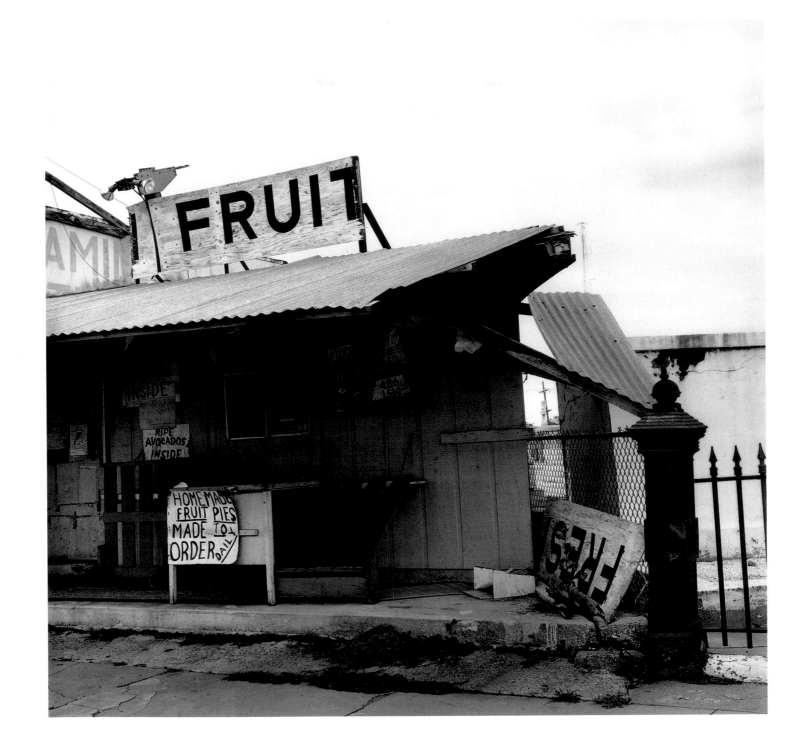

Sometimes the places were all cave paintings to her. She'd open the door and read the wall — what to eat, whom to speak to, what to say. She'd hold her fork carefully, order the house specialty pie, and wait for the fastest man in the room to come over and say, "Plastic stars. How did we ever live without them?"

S.S. BILL

AUG.14.1935

PHIL. DELCAMBER - LEANA
" " NITA AND C
E. J. DELCAMBER (1935)

NEW TB

SGT. JOHN J. LOUVIERE
W.W. II 785 TH. TANK B

Sunrise to sunset, the thing she was always ready to do was nail this down right now. Sometimes she got a couple hundred hits a day.

She told a guy named Spot, who was head-to-toe grease, that she had to carry everything with her. "It's all in my bag. Why leave it home? What if I die out here without my stuff? How would anybody know it was me?"

She closed her eyes and imagined a dress with bloodstains on it, a car wreck, ragged hair and ripped-open arms. She stayed awake all night pinned in sideways, like a little golden fish.

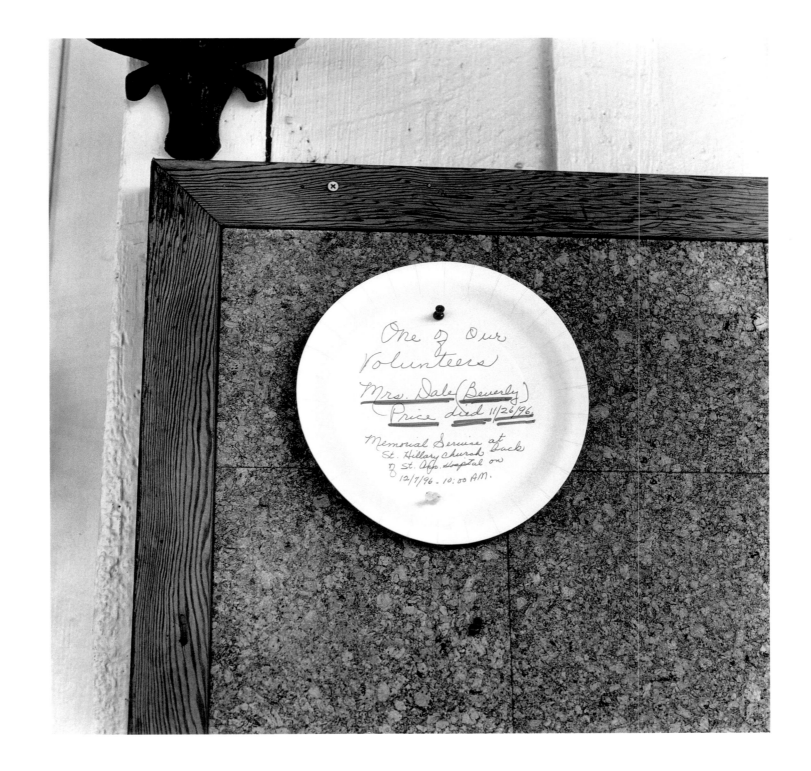

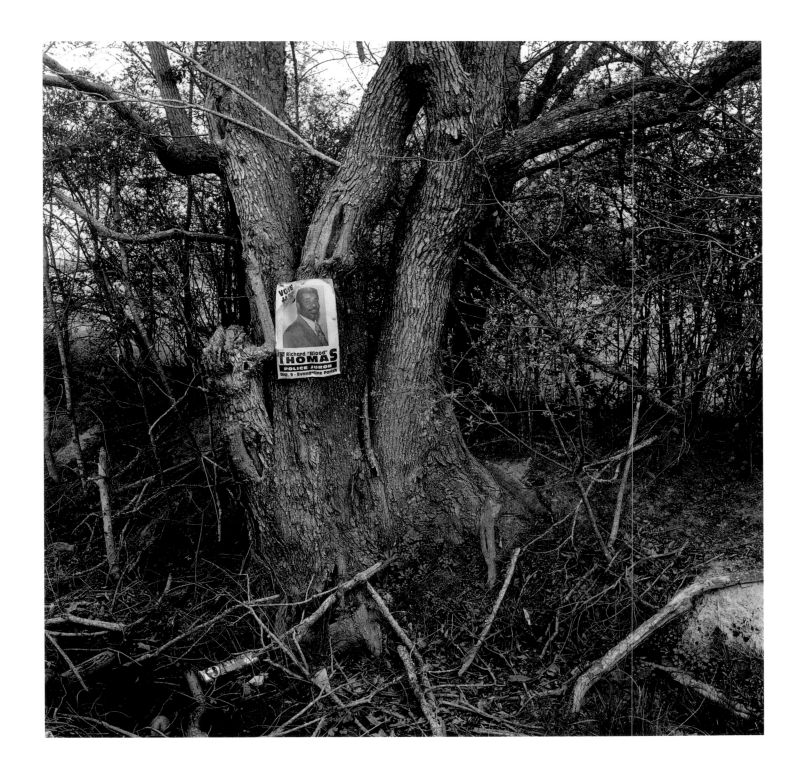

After dinner he took her out back of the bungalow and said, "Just be real quiet and nobody'll see us, nobody'll know we were ever here. We don't even have to talk to each other, we can just stay like this, you know? You and me. Real casual. Just stand there. Admire the bark on that one."

In a town called Quantum, Alabama, she was stopped by the Highway Patrol. They ran her tags and asked her if she knew what was happening. "It's a simple question," the puffed-up cop said. "Sit still there, will you? It's a simple question and it deserves a direct answer. We just want to know what you know and when you started knowing it. That's all we want."

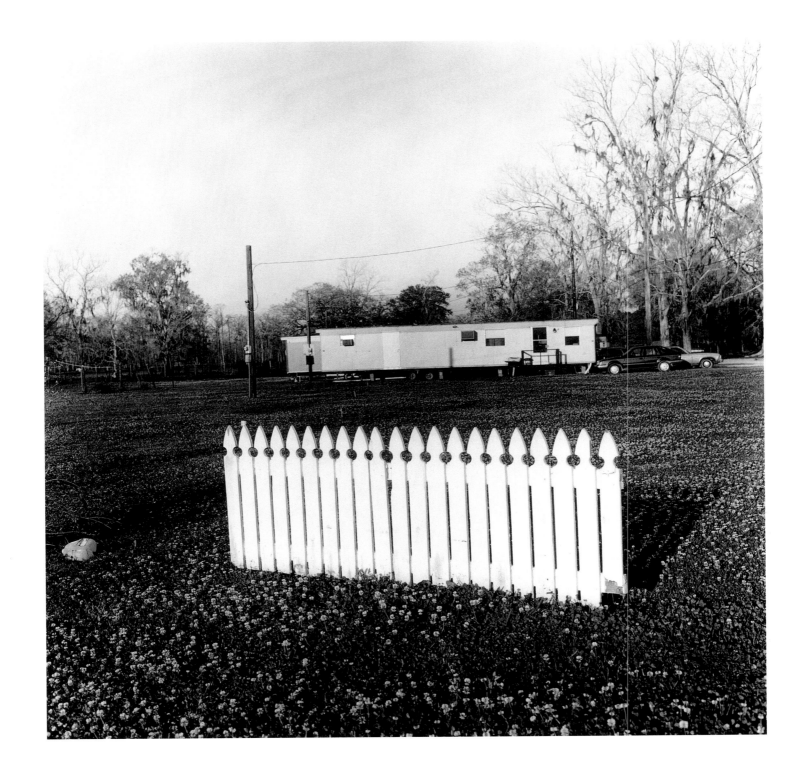

She sat for a while staring, thinking that there
was nothing like that feeling when you're all locked
up inside.

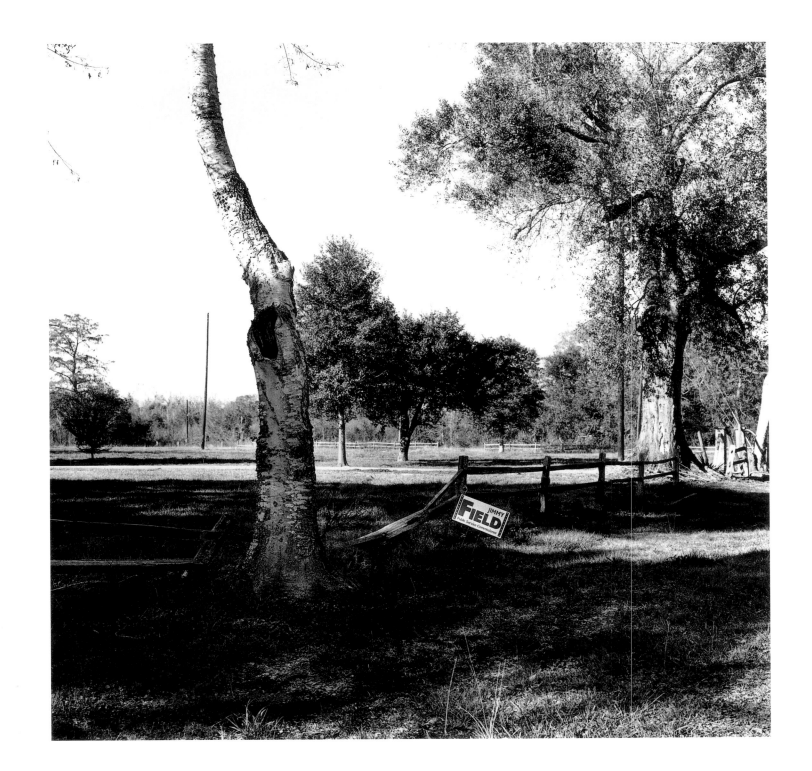

After two nights at the Carlsbad she was giving the hostess instructions. "Do it with flair, Billie. You stride into it, you swing your foot out, you let the wrist follow — you're presenting here, like a big meal, like a rabbit show. You want to burst out in sudden, fierce activity — passion. You want to glow. The rest of us are just in the congregation."

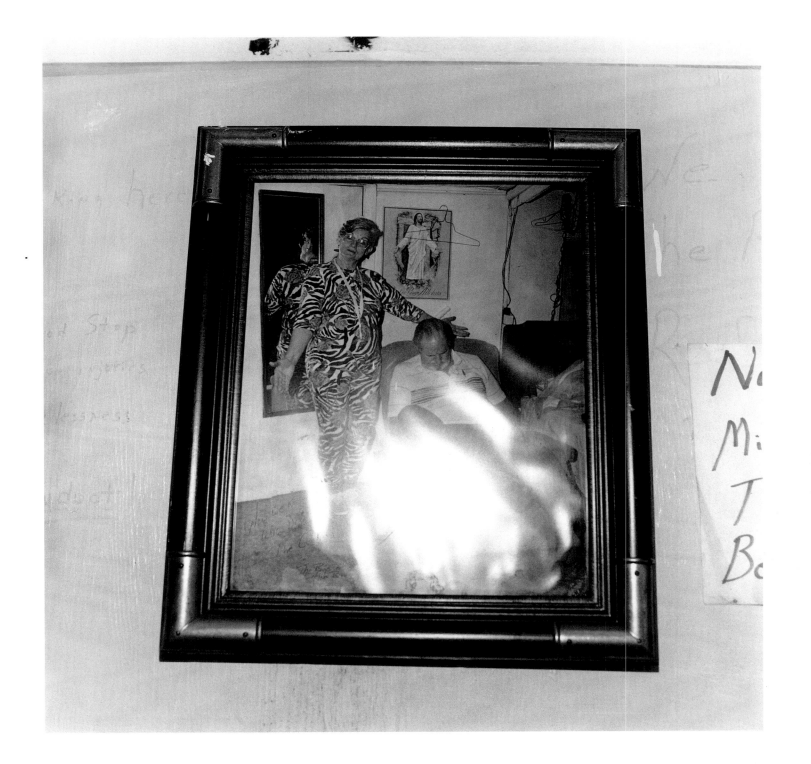

At the grocery in a town called Sunrise the light trickled over the bulletin board like luminous water. Everything she saw was constantly changing, flickering from what she'd just seen to what she was beginning to see. An unbroken breeze waved the surface, stirring the notes. After a while she uncovered an advertisement for a ceiling-fly supervisor, snapped it off the board, and slid it into the silk lining of her pocket.

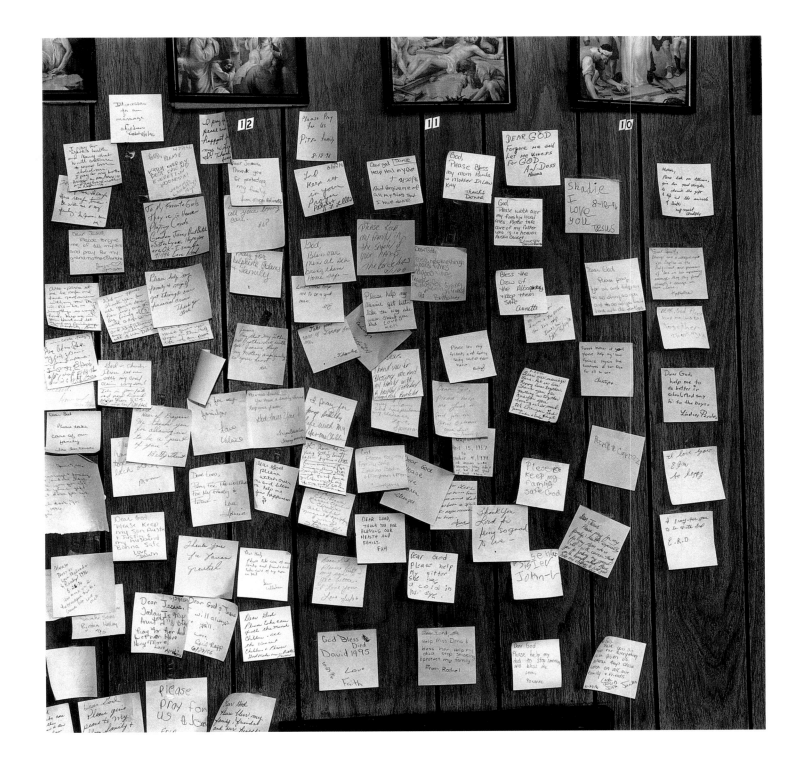

She didn't know which one to sit in, the big one with the flowers, or the round rubber one. She could see the road either way. She figured she'd recognize his truck by now.

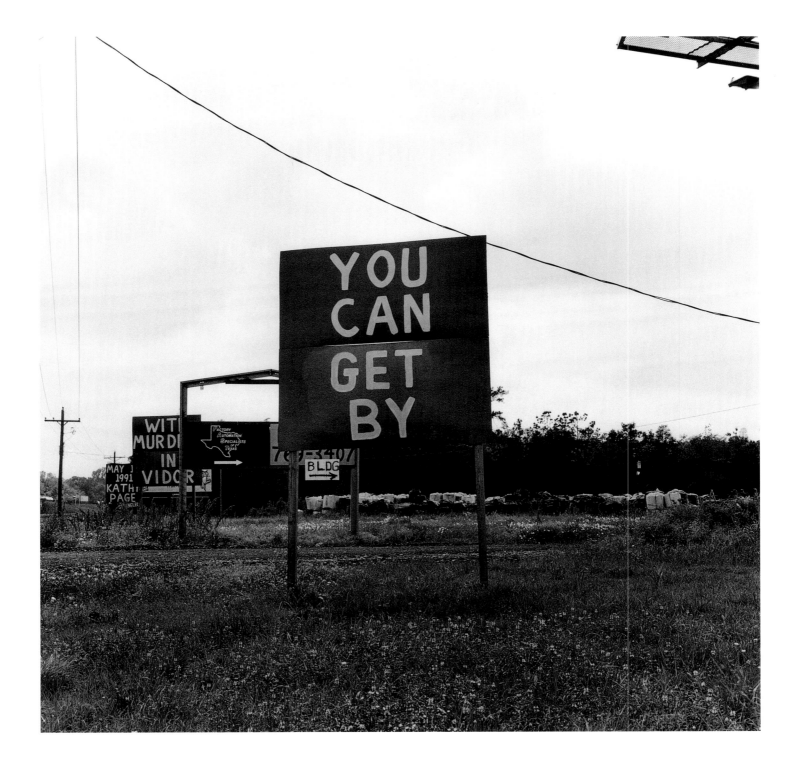

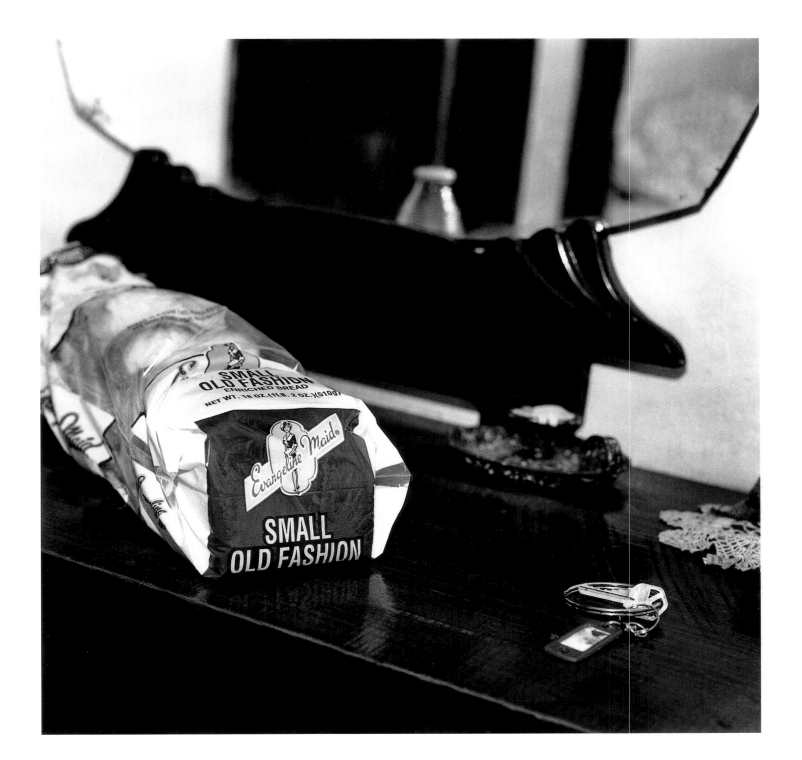

She went out and stood on the balcony for a few minutes, in the cool, late night air, watched the lights shimmer out over the river, the lights on the bridge that crossed over to Vidalia, the lights along the shores on both sides. The hotel was the tallest building in town, and there weren't any other tall buildings between her and the river, so the sky was a clear, dark dome, pinpointed with stars.

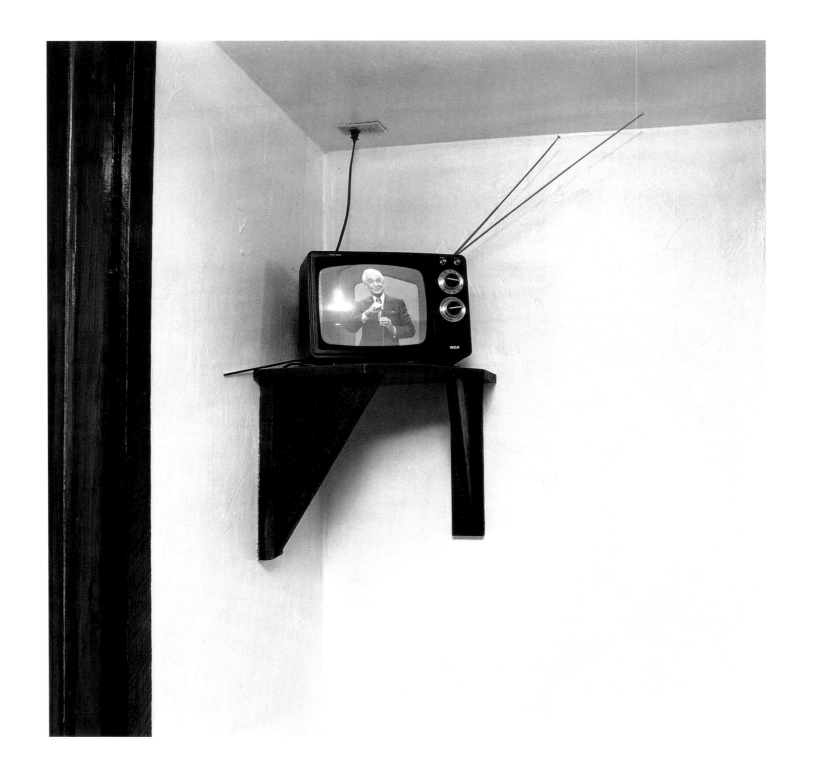

Everything in Monkey Town seemed small to her, even the ideas. She imagined people sitting in their little houses complaining about other people in town who were always doing things wrong, having their little precious thoughts, clinging to their ideas and opinions, arguing for what they believed.

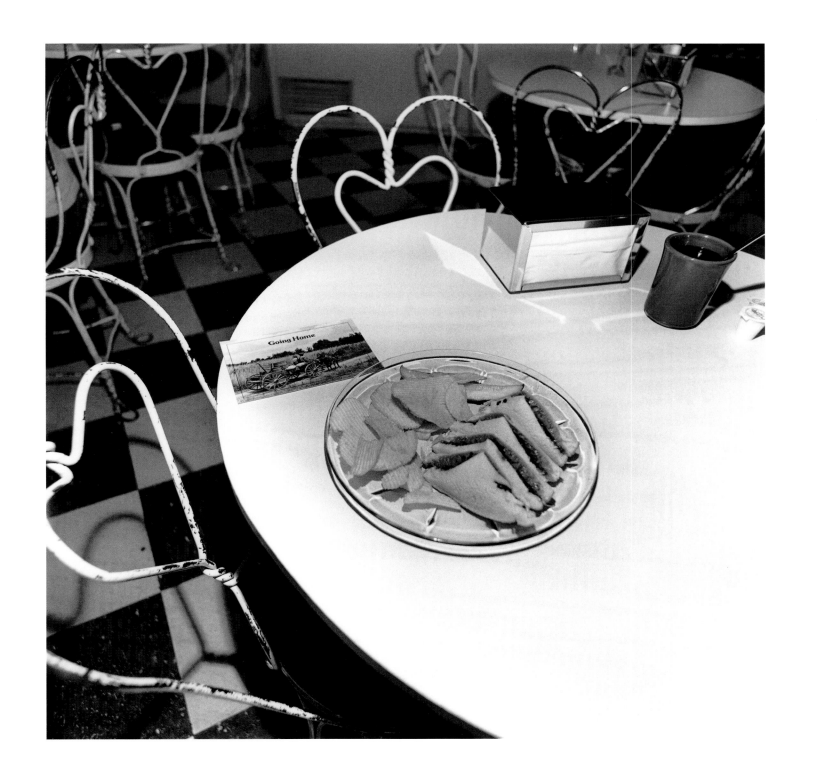

They were coming at us and they weren't stopping, they were never stopping. There were thousands of them. And there were more where those came from.

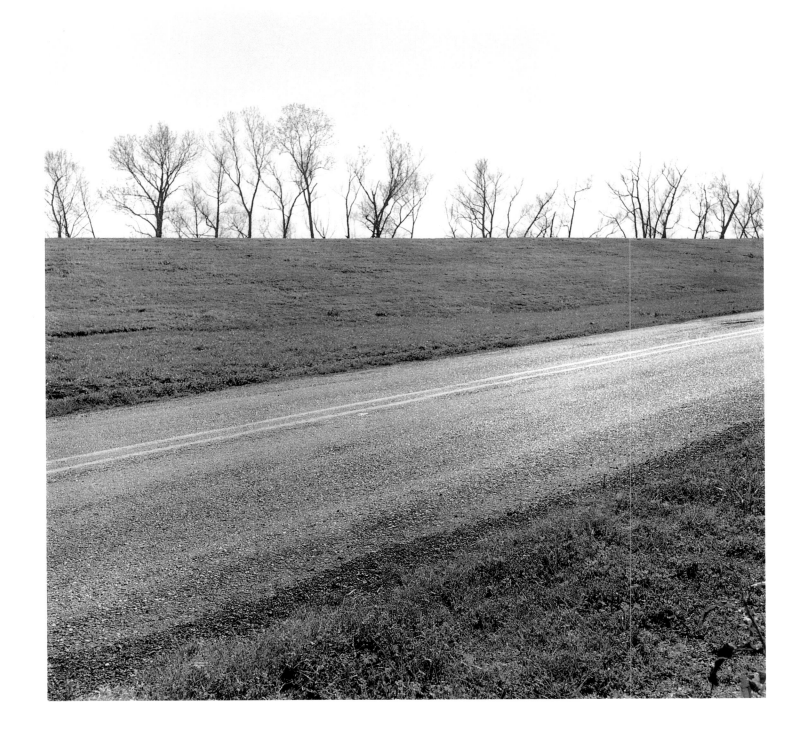

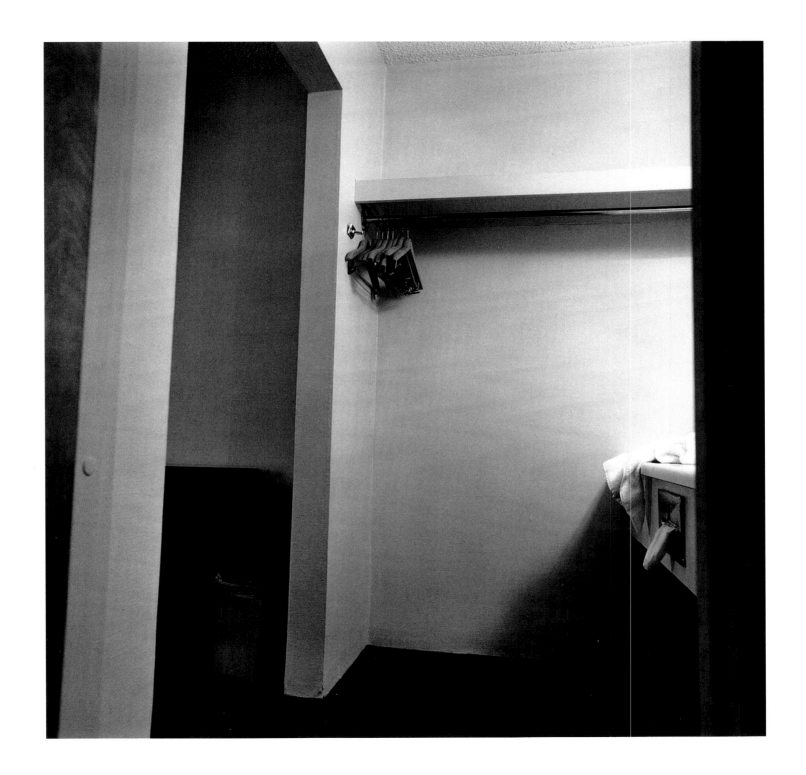

At Venice, Florida, she put something extra on the bill for the waiter, hoping the kid would notice and give her a chance to start something. His skin was movie-actor fresh. Last time, she knew, it had been different. Guy's brother killed in a car-train collision, how could she have known? And what if she turned out to be the mother of his children?

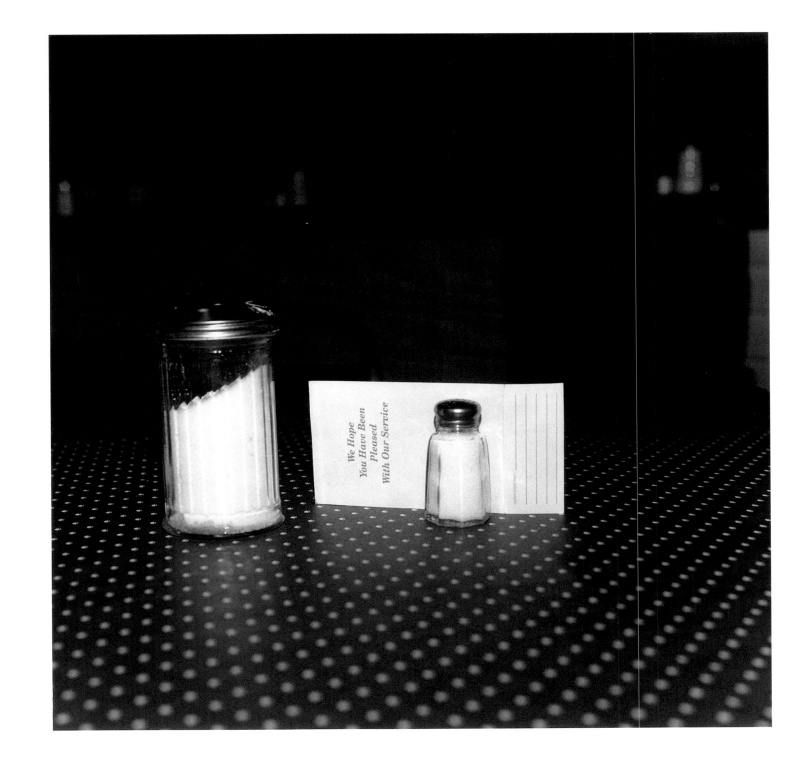

We Hope
You Have Been
Pleased
With Our Service

She was in constant touch. She reported that she'd seen a fish caught in the little orange castle in the tank. What did she mean by that? No one knew. It was some kind of code the two of them used.

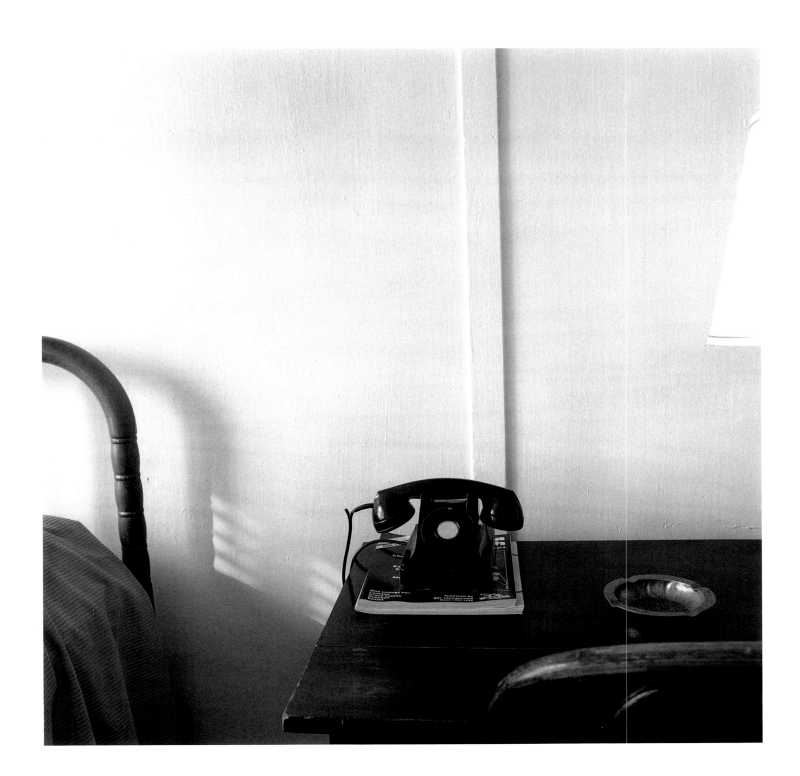

trip PHOTOGRAPHS BY SUSAN LIPPER

The commonplace is sometimes the most out of place. This is the paradox at the heart of this book.

Trip is a joyride through a landscape of imagery at once real and surreal. It takes us on a journey that begins and ends somewhere in the United States. Exactly where, or even when, is left for us to figure out, though the pictures bear the unmistakable imprint of the American South. Where else would one find a wall of photographs memorializing forty years of home-grown beauty queens with "girl-next-store" looks and names like Loretta, Corinne, Desiree, and Lonnie; a bathroom stall sporting a still from the Southern epic Gone with the Wind; or, perhaps most telling, a wall of devotional votive prayers inscribed on Post-it notes and stuck on a fake wood panel wall beneath dime-store images depicting the life of Jesus?

The America Lipper shows us is light-years away from the fashionable icons celebrated in Hollywood cinema or in the music industry. Instead, she places us into a cultural milieu that seems to rarely open itself up to outsiders, preferring to remain complacent in, if not wholly indifferent to, its anachronistic simplicity. This, at least, is the impression conveyed to readers who do not belong to this world.

As a visual essay documenting life on the road and conveyed to us "as is," Trip belongs to a rich literary and photographic tradition. Yet its spirit of discovery is not in the tradition of Jack Kerouac or Walker Evans. Trip presents a challenge to how we read images and create our own narratives in response. While it is inscribed with the aura of nostalgia and

objectivity inherent in traditional documentary work such as the Farm Security Administration photographs of the 1930s, Lipper's pictures countermand the authoritative clarity conveyed by those and other socially concerned images whose content is so direct that the possibility of multiple readings is closed off.

Though neither travelogue nor visual diary, this series of photographs has a journal-like structure — a beginning and an end, with various moments sandwiched in-between — but just as it seems to reveal certain facts about itself or the world it portrays, it deftly switches stream. Even its opening is a provocation: on a highway devoid of traffic signs and landmarks, vehicles run in opposing directions while the car closest to us has pulled over onto the shoulder of the road. We are left undecided whether we are coming or going, and what follows is no better at making any of this easy for us to discern. It also offers lighter moments — moments which are both insightful and funny — demonstrating how absurd reality can be. Just as the circumstances of many of the images are ambiguous, so too is the title. No longer understood as merely getting from point A to point B, "trip" can stand for everything from a psychedelic experience to someone or something that is beyond belief.

This ambiguity and uncertainty are lasting impressions, not as a sense of doubt about the meaning behind the work but more as the vagary that stems from trying to describe people, places, or events after the fact. So many of Lipper's pictures begin and end with this premise, forcing the viewer to create his or her own frame of reference to structure a meaning around the work, a meaning that can shift with

each individual reading. Time and again, it is unclear if her work is staged or spontaneously captured. Some of the images convey the imprint of intervention: the word "motel" scrawled in soap on a bathroom mirror, a scrambled-egg breakfast that looks like its picture in the menu, or a restaurant sign that charges us 93 cents for a small "slushpupp" while a large costs only 79 cents. Other works are more obviously the result of a random encounter: a white picket fence that keeps nothing in and no one out, a fresh-fruit stand that looks as decayed as a dump site, or an election poster, nailed to a tree in the middle of a rough bramble, for an African-American candidate for police juror with the nickname "Blood."

A key element binding us to these photographs is our familiarity with the heightened sense of awareness that we have when we travel. Uprooted from everyday surroundings, the traveler renders everything as new and unfamiliar so that even the most commonplace object or event seems somehow strange and exotic. It is Lipper's sensitivity to this "Twilight Zone" between familiarity and peculiarity that informs some of the most enduring and arresting images in this book: a television on a picnic table, a mannequin in the woods, or a death announcement written in elegant script on a paper plate tacked to a bulletin board. These are not isolated gestures. They are moments which occur again and again, interrupted here and there by periods of absurd normalcy. And while these images seem somehow personal and idiosyncratic, they also carry that faint air of something seen before, conveying an experience that all of us can identify with in one way or another.

This familiarity is offset by an odd silence that permeates this series. There is certainly nothing tame about its subjects; nor is its recontextualization of places and things passive. Yet despite the movement — the twists and the turns — the persistent absence of people in Lipper's images creates an ominous stillness. Composed of the traces and remnants of events past, Lipper's work leaves unanswered the mystery of who or what we are looking at. This in turn becomes a kind of reflection upon our own search for identity. It is a subtle yet poignant revelation, formed in the moments we reflect on the alternating peculiarity and familiarity of these images.

This identity crisis is exemplified by one of the series' darkly humorous moments — an image appropriated and then reappropriated. It's an old joke, appearing here as a hand-scrawled poster tacked to the side of a shed, about a lost dog who is castrated, blind, and missing a few other vital parts of his anatomy. He answers to the name "Lucky."

I'm still looking for him.

MATTHEW DRUTT

Matthew Drutt is Associate Curator for Research at the Solomon R. Guggenheim Museum, and serves as the lead curatorial advisor on photography, new media initiatives, design, and education.

This work has gone through many incarnations. I would like to express my gratitude collectively to the friends and colleagues that have stayed with me through the various stages. I would also like to mention those friends from "on the road" as well as, early supporters of this project. Special thanks are due to Dewi Lewis, Rick Barthelme, Joseph Guglietti, Laurent Girard, John Slyce, Joseph Lawton, Stephen Maklansky, Matthew Drutt, George Slade, Mark Stephen Massa, and those at powerHouse. S.L.

This book is dedicated to Sandy Gilbert Freidus and Marc Freidus.

SUSAN LIPPER, a New York-based photographer, is the author of the 1994 monograph, *GRAPEVINE* . A graduate of the Yale University MFA program, Lipper has exhibited both in the United States and abroad, and is included in many important public and private collections.

FREDERICK BARTHELME is the author of eleven other books of fiction, the most recent of which is *Bob The Gambler*. He directs the writing program at the University of Southern Mississippi, and edits the literary journal *Mississippi Review*.